Thurber, James, 1894-1961 Secret lives of Walter Mitty and of James Thurber c2006.

SANTA BARBARA PUBLIC LIBRARY
CENTRAL LIBRARY

Editor's Note

When we asked Marc Simont to illustrate a James Thurber story, *The Secret Life of Walter Mitty* was the obvious choice. However, when we realized that we had space for a second piece, the possibilities seemed endless.

And so we are particularly delighted to bring you *The Secret Life of James Thurber*, which, although not nearly as well known, is a worthy companion to Walter Mitty's story. The piece was rediscovered by Marc Simont and by Thurber's daughter, Rosemary. She told us that she had, by coincidence, recently found a letter in which her father refers to it as one of his favorites.

Who could ask for anything more. . . .

Secret Lives
of Walter Mitty
and of James Thurber

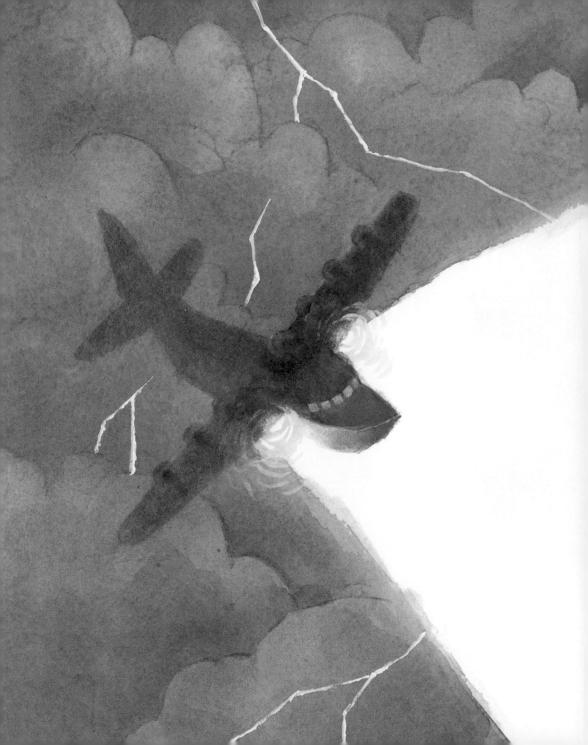

JAMES THURBER

Secret Lives
of Walter Mitty
and of James Thurber

ILLUSTRATED BY MARC SIMONT

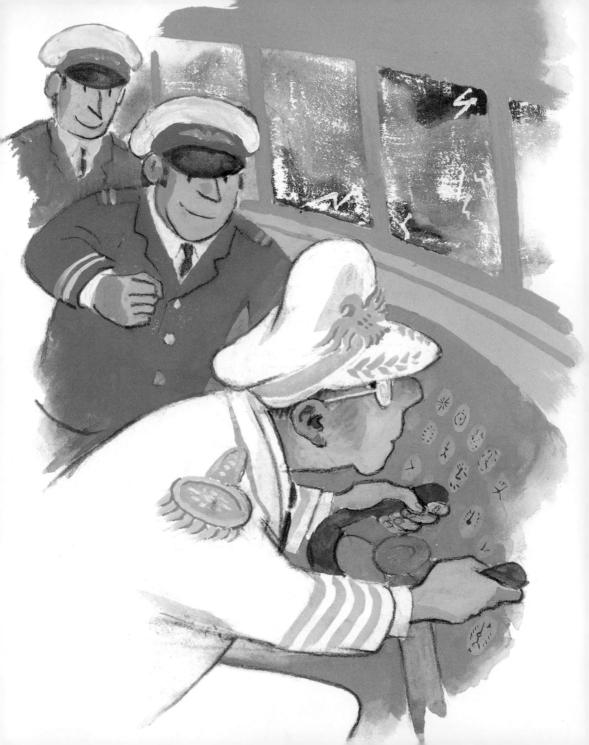

The Secret Life of Walter Mitty

"We're going through!" The Commander's voice was like thin ice breaking. He wore his full-dress uniform, with the heavily braided white cap pulled down rakishly over one cold gray eye. "We can't make it, sir. It's spoiling for a hurricane, if you ask me." "I'm not asking you, Lieutenant Berg," said the Commander. "Throw on the power lights! Rev her up to 8,500! We're going through!" The pounding of the cylinders increased: ta-pocketapocketa-pocketa-pocketa. The Commander stared at the ice forming on the pilot window. He walked over and twisted a row of complicated dials. "Switch on No. 8 auxiliary!" he shouted. "Switch on No. 8 auxiliary!" repeated Lieutenant Berg. "Full strength in No. 3 turret!" shouted the Commander. "Full strength in No. 3 turret!" The crew, bending to their various tasks in the huge, hurtling eight-engined Navy hydroplane, looked at each other and grinned. "The Old Man'll get us through," they said to one another. "The Old Man ain't afraid of Hell!" . . .

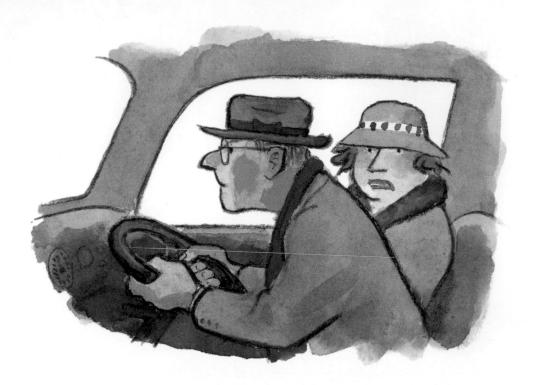

"Not so fast! You're driving too fast!" said Mrs. Mitty. "What are you driving so fast for?"

"Hmm?" said Walter Mitty. He looked at his wife, in the seat beside him, with shocked astonishment. She seemed grossly unfamiliar, like a strange woman who had yelled at him in a crowd. "You were up to fifty-five," she said. "You know I don't like to go more than forty. You were up to fifty-five." Walter Mitty drove on toward Waterbury in silence, the roaring of the SN202 through the worst storm in twenty years of Navy flying faded in the remote, intimate airways of his mind. "You're tensed up again,"

said Mrs. Mitty. "It's one of your days. I wish you'd let Dr. Renshaw look you over."

Walter Mitty stopped the car in front of the building where his wife went to have her hair done. "Remember to get those overshoes while I'm having my hair done," she said. "I don't need overshoes," said Mitty. She put her mirror back into her bag. "We've been all through that," she said, getting out of the car. "You're not a young man any longer." He raced the engine a little. "Why don't you wear your gloves? Have you lost your gloves?" Walter Mitty reached in a pocket and brought out the gloves. He put them on, but after she had turned and gone into the building and he had driven on to a red light, he took them off again. "Pick it up, brother!" snapped a cop as the light changed, and Mitty hastily pulled on his gloves and lurched ahead. He drove around the streets aimlessly for a time, and then he drove past the hospital on his way to the parking lot.

... "It's the millionaire banker, Wellington McMillan," said the pretty nurse. "Yes?" said Walter Mitty, removing his gloves slowly. "Who has the case?" "Dr. Renshaw and Dr. Benbow, but there are two specialists here, Dr. Remington from New York and Mr. Pritchard-Mitford from London. He flew over." A door opened

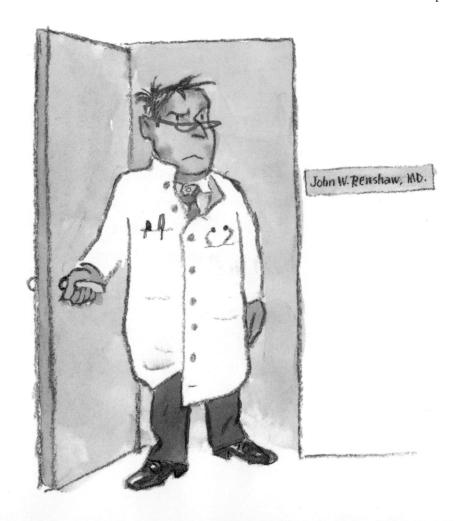

down a long, cool corridor and Dr. Renshaw came out. He looked distraught and haggard. "Hello, Mitty," he said. "We're having the devil's own time with McMillan, the millionaire banker and close personal friend of Roosevelt. Obstreosis of the ductal tract.

Tertiary. Wish you'd take a look at him." "Glad to," said Mitty.

In the operating room there were whispered introductions:
"Dr. Remington, Dr. Mitty. Mr. Pritchard-Mitford, Dr. Mitty."
"I've read your book on streptothricosis," said Pritchard-Mitford, shaking hands. "A brilliant performance, sir." "Thank you," said Walter Mitty. "Didn't know you were in the States, Mitty," grumbled Remington. "Coals to Newcastle, bringing Mitford and me up here for a tertiary." "You are very kind," said Mitty.

A huge, complicated machine, connected to the operating table, with many tubes and wires, began at this moment to go pocketa-pocketa-pocketa. "The new anesthetizer is giving way!" shouted an intern. "There is no one in the East who knows how to fix it!" "Quiet, man!" said Mitty, in a low, cool voice. He sprang to the machine, which was now going pocketa-pocketa-queep-pocketa-queep.

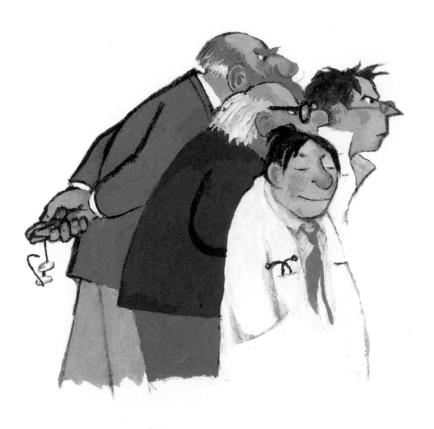

He began fingering delicately a row of glistening dials. "Give me a fountain pen!" he snapped. Someone handed him a fountain pen. He pulled a faulty piston out of the machine and inserted the pen in its place. "That will hold for ten minutes," he said. "Get on with the operation." A nurse hurried over and whispered to Renshaw, and Mitty saw the man turn pale. "Coreopsis has set in,"

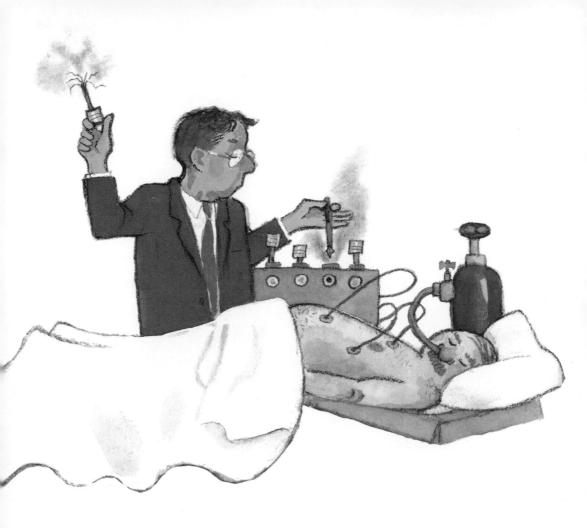

said Renshaw nervously. "If you would take over, Mitty?" Mitty looked at him and at the craven figure of Benbow, who drank, and at the grave, uncertain faces of the two great specialists. "If you wish," he said. They slipped a white gown on him; he adjusted a mask and drew on thin gloves; nurses handed him shining . . .

"Back it up, Mac! Look out for that Buick!" Walter Mitty jammed on the brakes. "Wrong lane, Mac," said the parking-lot attendant, looking at Mitty closely. "Gee. Yeh," muttered Mitty. He began cautiously to back out of the lane marked "Exit Only." "Leave her sit there," said the attendant. "I'll put her away." Mitty got out of the car. "Hey, better leave the key." "Oh," said Mitty, handing the man the ignition key. The attendant vaulted into the car, backed it up with insolent skill, and put it where it belonged.

They're so damn cocky, thought Walter Mitty, walking along Main Street; they think they know everything. Once he had tried to take his chains off, outside New Milford, and he had got them wound around the axles. A man had had to come out in a wrecking car and unwind them, a young, grinning garageman. Since then Mrs. Mitty always made him drive to a garage to have the chains taken off. The next time, he thought, I'll wear my right arm in a sling; they won't grin at me then.

I'll have my right arm in a sling and they'll see I couldn't possibly take the chains off myself.

He kicked at the slush on the sidewalk. "Overshoes," he said to himself, and he began looking for a shoe store.

When he came out into the street again, with the overshoes in a box under his arm, Walter Mitty began to wonder what the other thing was his wife had told him to get. She had told him twice, before they set out from their house for Waterbury. In a way he hated these weekly trips to town—he was always getting something wrong. Kleenex, he thought, Squibb's, razor blades? No. Toothpaste, toothbrush, bicarbonate, carborundum, initiative and referendum? He gave it up. But she would remember it. "Where's the what's-itsname?" she would ask. "Don't tell me you forgot the what's-itsname." A newsboy went by shouting something about the Waterbury trial.

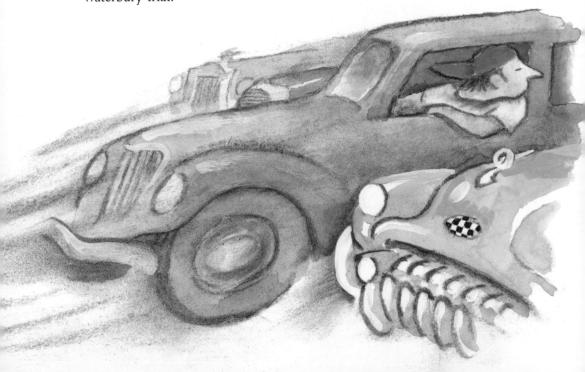

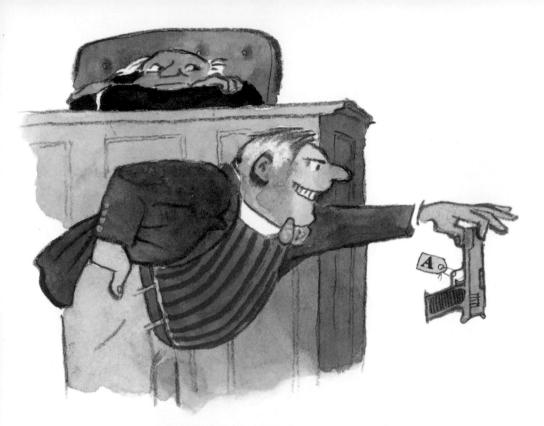

Attorney suddenly thrust a heavy automatic at the quiet figure on the witness stand. "Have you ever seen this before?" Walter Mitty took the gun and examined it expertly. "This is my Webley-Vickers 50.80," he said calmly. An excited buzz ran around the courtroom. The judge rapped for order. "You are a crack shot with any sort of firearms, I believe?" said the District Attorney, insinuatingly. "Objection!" shouted Mitty's attorney. "We have shown that the defendant could not have fired the shot. We have shown that he

wore his right arm in a sling on the night of the fourteenth of July." Walter Mitty raised his hand briefly and the bickering attorneys were stilled. "With any known make of gun," he said evenly, "I could have killed Gregory Fitzhurst at three hundred feet with my left hand." Pandemonium broke loose in the courtroom.

A woman's scream rose above the bedlam and suddenly a lovely, dark-haired girl was in Walter Mitty's arms. The District Attorney struck at her savagely.

Without rising from his chair, Mitty let the man have it on the point of the chin. "You miserable cur!" . . .

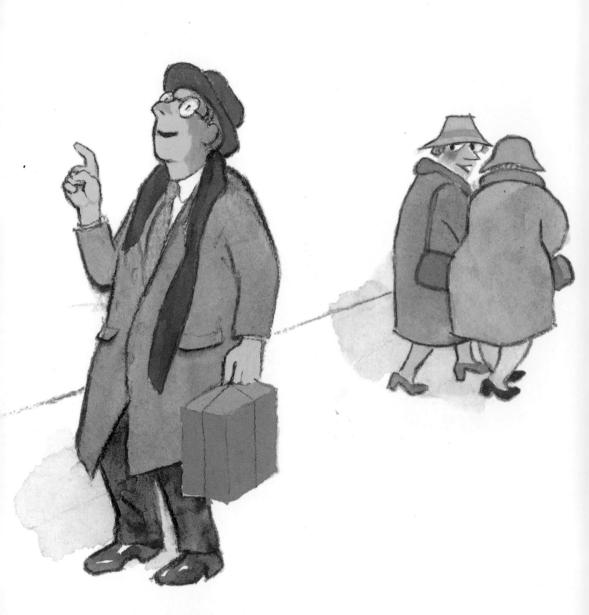

"Puppy biscuit," said Walter Mitty. He stopped walking and the buildings of Waterbury rose up out of the misty courtroom and surrounded him again. A woman who was passing laughed. "He said 'puppy biscuit," she said to her companion. "That man said 'puppy biscuit' to himself." Walter Mitty hurried on. He went into an A&P, not the first one he came to but a smaller one farther up the street. "I want some biscuit for small, young dogs," he said to the clerk. "Any special brand, sir?" The greatest pistol shot in the world thought a moment. "It says 'Puppies Bark for It' on the box," said Walter Mitty.

His wife would be through at the hairdresser's in fifteen minutes, Mitty saw in looking at his watch, unless they had trouble drying it; sometimes they had trouble drying it. She didn't like to get to the hotel first; she would want him to be there waiting for her as usual. He found a big leather chair in the lobby, facing a window, and he put the overshoes and the puppy biscuit on the floor beside it. He picked up an old copy of *Liberty* and sank down into the chair. "Can Germany Conquer the World Through the Air?" Walter Mitty looked at the pictures of bombing planes and of ruined streets.

... "The cannonading has got the wind up in young Raleigh, sir," said the sergeant. Captain Mitty looked up at him through tousled hair. "Get him to bed," he said wearily. "With the others. I'll fly alone." "But you can't, sir," said the sergeant anxiously. "It takes two men to handle that bomber and the Archies are pounding hell out of the air. Von Richtman's circus is between here and Saulier." "Somebody's got to get that ammunition dump," said Mitty. "I'm going over. Spot of brandy?" He poured a drink for the sergeant and one for himself. War thundered and whined around the dugout and battered at the door. There was a rending of wood and splinters flew through the room. "A bit of a near thing," said Captain Mitty carelessly. "The box barrage is closing in," said the sergeant. "We only live once, Sergeant," said Mitty, with his faint, fleeting smile. "Or do we?" He poured another brandy and tossed it off. "I never see a man could hold his brandy like you, sir," said the sergeant. "Begging your pardon, sir." Captain Mitty stood up and strapped on his huge Webley-Vickers automatic. "It's forty kilometers through hell, sir," said the sergeant. Mitty finished one last brandy. "After all," he said softly, "what isn't?" The pounding of the cannon increased; there was the rat-tat-tatting of machine guns, and from somewhere came the menacing pocketa-pocketa of the new flame-throwers. Walter Mitty walked to the door of the dugout humming "Auprès de Ma Blonde." He turned and waved to the sergeant. "Cheerio!" he said. . . .

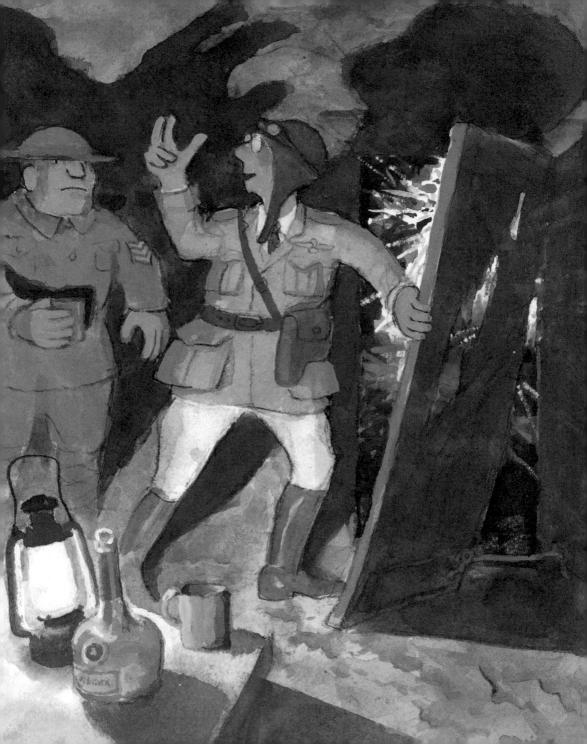

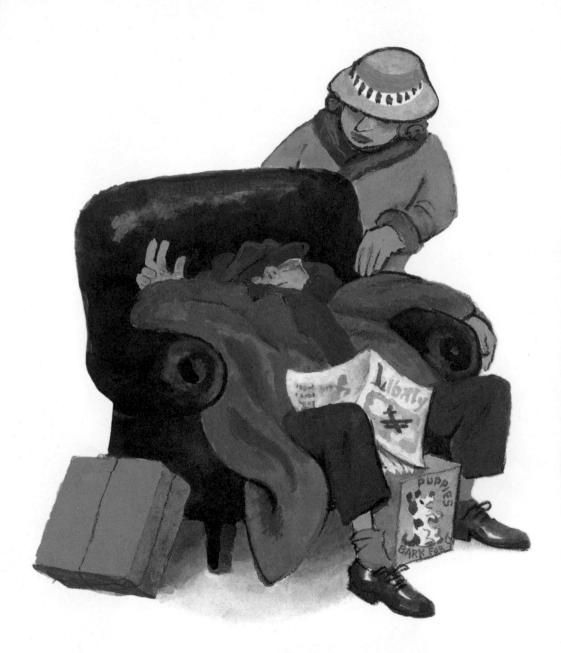

Something struck his shoulder. "I've been looking all over this hotel for you," said Mrs. Mitty. "Why do you have to hide in this old chair? How did you expect me to find you?" "Things close in," said Walter Mitty vaguely. "What?" Mrs. Mitty said. "Did you get the what's-its-name? The puppy biscuit? What's in that box?" "Overshoes," said Mitty. "Couldn't you have put them on in the store?" "I was thinking," said Walter Mitty. "Does it ever occur to you that I am sometimes thinking?" She looked at him. "I'm going to take your temperature when I get you home," she said.

They went through the revolving doors that made a faintly derisive whistling sound when you pushed them. It was two blocks to the parking lot. At the drugstore on the corner she said, "Wait here for me. I forgot something. I won't be a minute." She was more than a minute. Walter Mitty lighted a cigarette. It began to rain, rain with sleet in it. He stood up against the wall of the drugstore, smoking. . . .

He put his shoulders back and his heels together. "To hell with the handkerchief," said Walter Mitty scornfully. He took one last drag on his cigarette and snapped it away. Then, with that faint, fleeting smile playing about his lips, he faced the firing squad; erect and motionless, proud and disdainful, Walter Mitty the Undefeated, inscrutable to the last.

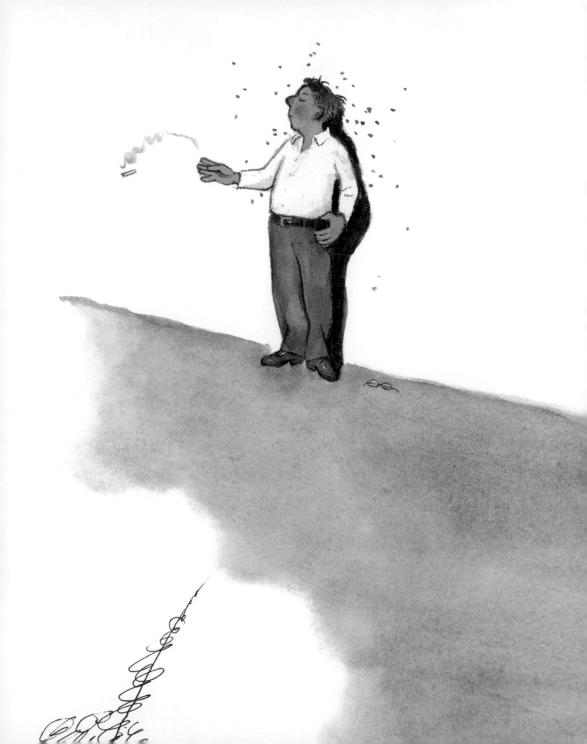

The Secret Life of James Thurber

have only dipped here and there into Salvador Dalí's *The Secret Life of Salvador Dalí* (with paintings by Salvador Dalí and photographs of Salvador Dalí), because anyone afflicted with what my grandmother's sister Abigail called "the permanent jumps" should do no more than skitter through such an autobiography, particularly in these melancholy times.

One does not have to skitter far before one comes upon some vignette which gives the full shape and flavor of the book: the youthful dreamer of dreams biting a sick bat or kissing a dead horse, the slender stripling going into man's estate with the high hope and fond desire of one day eating a live but roasted turkey, the sighing lover covering himself with goat dung and aspic that he might give off the true and noble odor of the ram. In my flying trip through Dalí I caught other glimpses of the great man: Salvador adoring a seed ball fallen from a plane tree, Salvador kicking a tiny playmate off a bridge, Salvador caressing a crutch, Salvador breaking the old family doctor's glasses with a leatherthonged mattress-beater. There would appear to be only two things in the world that revolt him (and I don't mean a long-dead hedgehog). He is squeamish about skeletons and grasshoppers. Oh, well, we all have our idiosyncrasies.

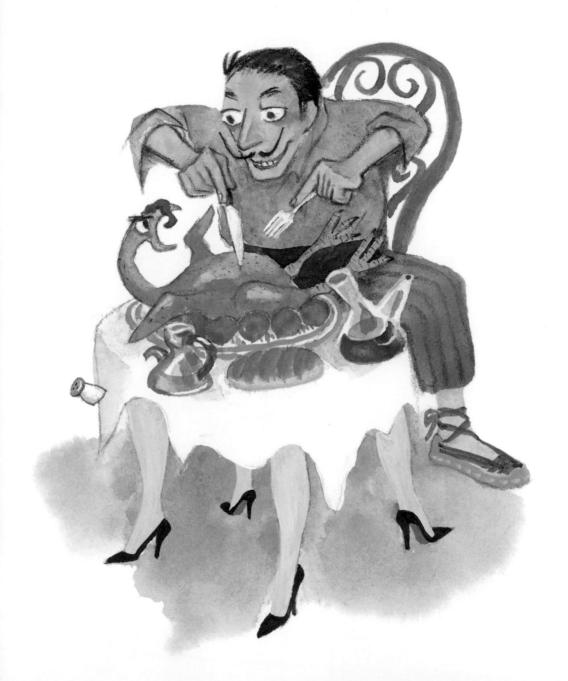

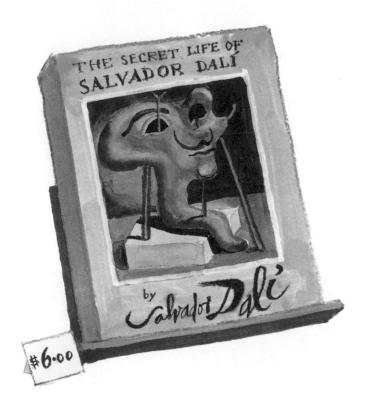

Señor Dalí's memoirs have set me to thinking. I find myself muttering as I shave, and on two occasions I have swung my crutch at a little neighbor girl on my way to the post office. Señor Dalí's book sells for six dollars. My own published personal history (Harper & Brothers, 1933) sold for \$1.75. At the time I complained briefly about this unusual figure,

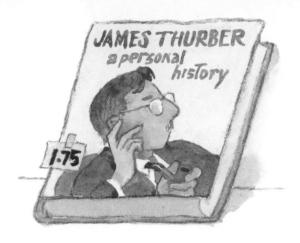

principally on the ground that it represented only fifty cents more than the price asked for a book called *The Adventures of Horace the Hedgehog*, published the same month. The publishers explained that the price was a closely approximated vertical, prefigured on the basis of profitable ceiling, which in turn was arrived at by taking into consideration the effect on diminishing returns of the horizontal factor.

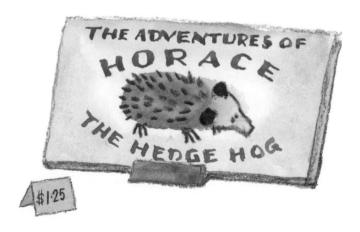

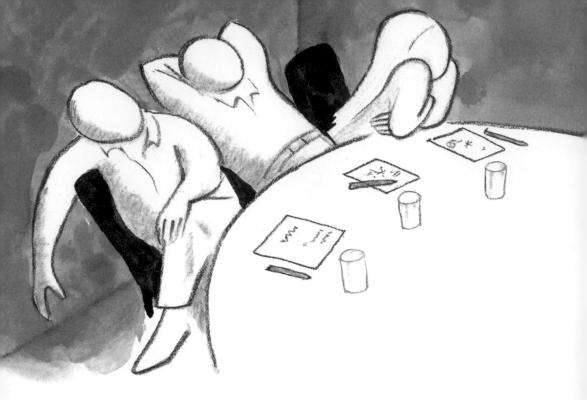

In those days all heads of business firms adopted a guarded kind of double talk, commonly expressed in low, muffled tones, because nobody knew what was going to happen and nobody understood what had. Big business had been frightened by a sequence of economic phenomena which had clearly demonstrated that our civilization was in greater danger of being turned off than of gradually crumbling away. The upshot of it all was that I accepted the price of \$1.75. In so doing, I accepted the state of the world as a proper standard by which the price of books should be fixed. And now, with the world in ten times as serious a condition as it was in 1933, Dalí's publishers set a price of six dollars on his life

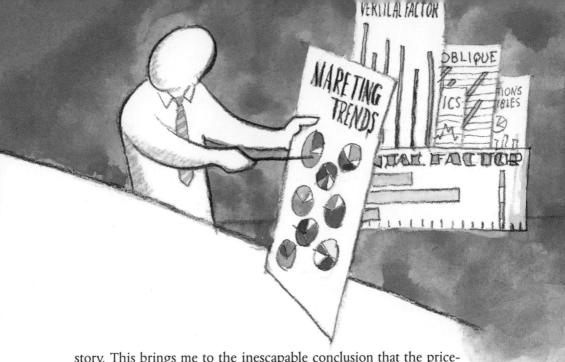

story. This brings me to the inescapable conclusion that the price-fixing principle, in the field of literature, is not global but personal. The trouble, quite simply, is that I told too much about what went on in the house I lived in and not enough about what went on inside myself.

Let me be the first to admit that the naked truth about me is to the naked truth about Salvador Dalí as an old ukulele in the attic is to a piano in a tree, and I mean a piano with breasts. Señor Dalí has the jump on me from the beginning. He remembers and describes in detail what it was like in the womb. My own earliest memory is of accompanying my father to a polling booth in Columbus, Ohio, where he voted for William McKinley.

It was a drab and somewhat battered tin shed set on wheels, and it was filled with guffawing men and cigar smoke; all in all. as far removed from the paradisiacal placenta of Salvador Dalí's first recollection as could well be imagined. A fat, jolly man dandled me on his knee and said that I would soon be old enough to vote against William Jennings Bryan. I thought he meant that I could push a folded piece of paper into the slot of the padlocked box as soon as my father was finished. When this turned out not to be true, I had to be carried out of the place kicking and screaming. In my struggles I knocked my father's derby off several times. The derby was not a monstrously exciting love object to me, as practically everything Salvador encountered was to him, and I doubt, if I had that day to live over again, that I could bring myself, even in the light of exotic dedication as I now know it, to conceive an intense and perverse affection for the derby. It remains obstinately in my memory as a rather funny hat, a little too large in the crown, which gave my father the appearance of a tired, sensitive gentleman who had been persuaded against his will to take part in a game of charades.

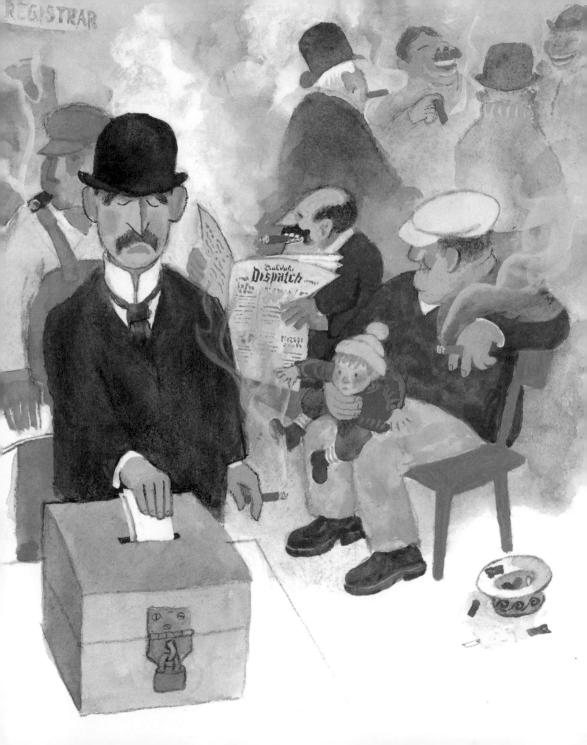

We lived on Champion Avenue at the time, and the voting booth was on Mound Street. As I set down these names, I begin to perceive an essential and important difference between the infant Salvador and the infant me. This difference can be stated in terms of environment. Salvador was brought up in Spain, a country colored by the legends of Hannibal, El Greco, and Cervantes. I was brought up in Ohio, a region steeped in the tradition of Coxey's Army, the Anti-Saloon League, and William Howard Taft.

It is only natural that the weather in little Salvador's soul should have been stirred by stranger winds and enveloped in more fantastic mists than the weather in my own soul. But enough of mewling apology for my lackluster early years. Let us get back to my secret life, such as it was, stopping just long enough to have another brief look at Señor Dalí on our way.

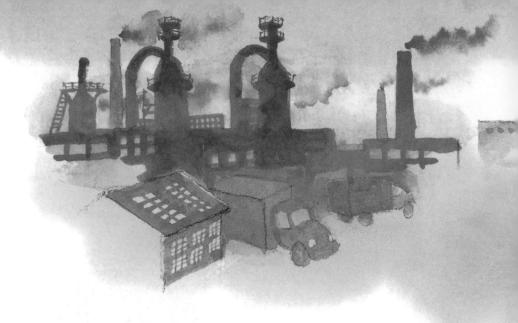

Salvador Dalí's mind goes back to a childhood half imagined and half real, in which the edges of actuality were sometimes less sharp than the edges of dream. He seems somehow to have got the idea that this sets him off from Harry Spencer, Charlie Doakes, I. Feinberg, J. J. McNaboe, Willie Faulkner, Herbie Hoover, and me. What Salvie had that the rest of us kids didn't was the perfect scenery, characters, and costumes for his desperate little rebellion against the clean, the conventional, and the comfortable. He put perfume on his hair (which would have cost him his life in, say, Bayonne, N. J., or Youngstown, Ohio), he owned a lizard with two tails, he wore silver buttons on his shoes, and he knew, or imagined he knew, little girls named Galuchka and Dullita. Thus he was born

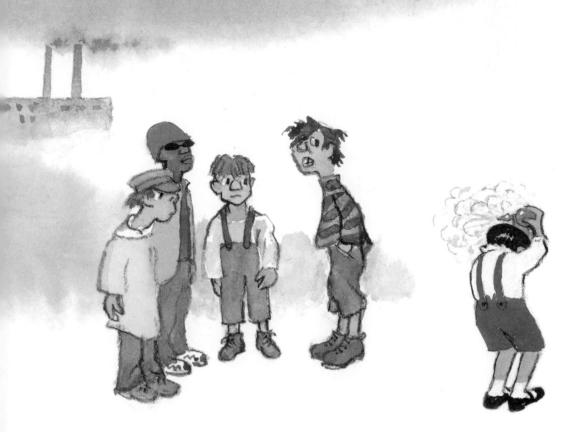

halfway along the road to paranoia, the soft Poictesme of his prayers, the melting Oz of his oblations, the capital, to put it so that you can see what I am trying to say, of his heart's desire. Or so, anyway, it must seem to a native of Columbus, Ohio, who, as a youngster, bought his twelve-dollar suits at the F. & R. Lazarus Co., had his hair washed out with Ivory soap, owned a bull terrier with only one tail, and played (nicely and a bit diffidently) with little girls named Irma and Betty and Ruby.

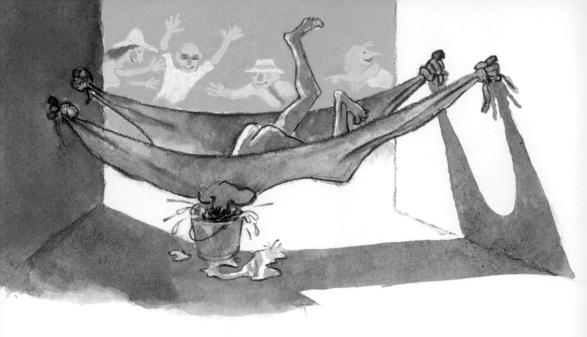

Another advantage that the young Dalí had over me, from the standpoint of impetus toward paranoia, lay in the nature of the adults who peopled his real world. There was, in Dalí's home town of Figueras, a family of artists named Pitchot (musicians, painters, and poets), all of whom adored the ground that the *enfant terrible* walked on. If one of them came upon him throwing himself from a high rock—a favorite relaxation of our hero—or hanging by his feet with his head immersed in a pail of water, the wild news was spread about the town that greatness and genius had come to Figueras. There was a woman who put on a look of maternal interest when Salvador threw rocks at her. The mayor of the town

fell dead one day at the boy's feet. A doctor in the community (not the one he had horsewhipped) was seized of a fit and attempted to beat him up. (The contention that the doctor was out of his senses at the time of the assault is Dalí's, not mine.)

The adults around me when I was in short pants were neither so glamorous nor so attentive. They consisted mainly of eleven maternal great-aunts, all Methodists, who were staunch believers in physic, mustard plasters, and Scripture, and it was part of their dogma that artistic tendencies should be treated in the same way as hiccups or hysterics. None of them was an artist, unless you can count Aunt Lou, who wrote sixteen-stress verse, with hit-and-miss rhymes, in celebration of people's birthdays or on the occasion

of great national disaster. It never occurred to me to bite a bat in my aunts' presence or to throw stones at them. There was one escape, though: my secret world of idiom.

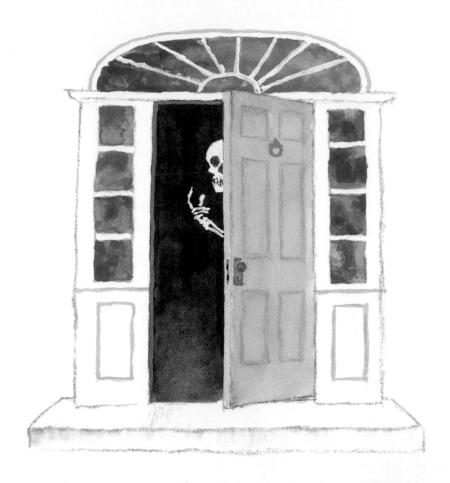

Two years ago my wife and I, looking for a house to buy, called on a firm of real-estate agents in New Milford. One of the members of the firm, scrabbling through a metal box containing many keys, looked up to say, "The key to the Roxbury house isn't here." His partner replied, "It's a common lock. A skeleton will let you in." I was suddenly once again five years old, with wide eyes

and open mouth. I pictured the Roxbury house as I would have pictured it as a small boy, a house of such dark and nameless horrors as have never crossed the mind of our little bat-biter.

It was sentences like that, nonchalantly tossed off by real-estate dealers, great-aunts, clergymen, and other such prosaic persons that the enchanted private world of my early boyhood was made. In this world, businessmen who phoned their wives to say that they were tied up at the office sat roped to their swivel chairs, and probably gagged, unable to move or speak, except somehow, miraculously, to telephone; hundreds of thousands of businessmen tied to their chairs in hundreds of thousands of offices in every city of my fantastic cosmos. An especially fine note about the binding of all the businessmen in all the cities was that whoever did it always did it around five o'clock in the afternoon.

Then there was the man who left town under a cloud. Sometimes I saw him all wrapped up in the cloud, and invisible, like a cat in a burlap sack. At other times it floated, about the size of a sofa, three or four feet above his head, following him wherever he went. One could think about the man under the cloud before he went to sleep; the image of him wandering around from town to town was a sure soporific.

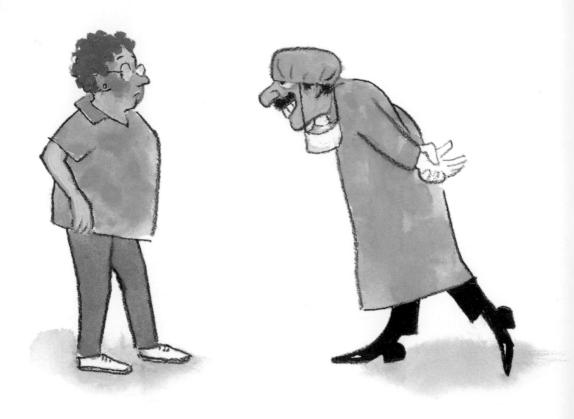

Not so the mental picture of a certain Mrs. Huston, who had been terribly cut up when her daughter died on the operating table. I could see the doctors too vividly, just before they set upon Mrs. Huston with their knives, and I could hear them. "Now, Mrs. Huston, will we get up on the table like a good girl, or will we have to be put there?" I could usually fight off Mrs. Huston

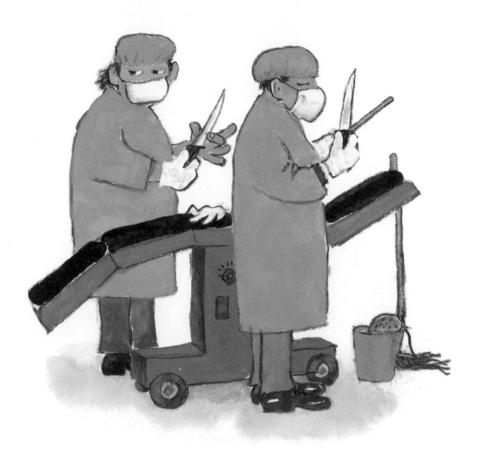

before I went to sleep, but she frequently got into my dreams, and sometimes she still does.

I remember the grotesque creature that came to haunt my meditations when one evening my father said to my mother, "What did Mrs. Johnson say when you told her about Betty?" and my mother replied, "Oh, she was all ears."

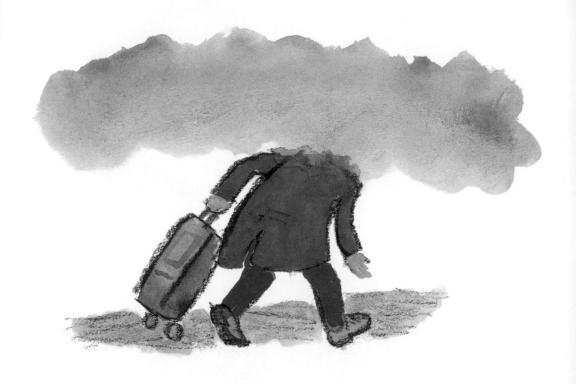

There were many other wonderful figures in the secret, surrealist landscapes of my youth: the old lady who was always up in the air, the husband who did not seem to be able to put his foot down, the man who lost his head during a fire but was still able to run out of the house yelling, the young lady who was, in reality, a soiled dove. It was a world that, of necessity, one had to keep to oneself and brood over in silence, because it would fall to pieces at the touch of words. If you brought it out into the light of actual

day and put it to the test of questions, your parents would try to laugh the miracles away, or they would take your temperature and put you to bed. (Since I always ran a temperature, whenever it was taken, I was put to bed and left there all alone with Mrs. Huston.)

Such a world as the world of my childhood is, alas, not year-proof. It is a ghost that, to use Henley's words, gleams, flickers, vanishes away. I think it must have been the time my little Cousin Frances came to visit us that it began surely and forever to dissolve. I came into the house one rainy dusk and asked where Frances was. "She is," said our cook, "up in the front room crying her heart out." The fact that a person could cry so hard that his heart would come out of his body, as perfectly shaped and glossy as a red velvet pincushion, was news to me. For some reason I had never heard the expression, so common in American families whose hopes and dreams run so often counter to attainment. I went upstairs and opened the door of the front room. Frances, who was three years older than I, jumped up off the bed and ran past me, sobbing, and down the stairs.

My search for her heart took some fifteen minutes. I tore the bed apart and kicked up the rugs and even looked in the bureau drawers. It was no good. I looked out the window at the rain and the darkening sky. My cherished mental image of the man under the cloud began to grow dim and fade away. I discovered that, all alone in a room, I could face the thought of Mrs. Huston with cold equanimity. Downstairs, in the living room, Frances was still crying. I began to laugh.

Ah there, Salvador!

SECRET LIVES OF WALTER MITTY AND OF JAMES THURBER
Text copyright © 2006 by Thurber Text and Thurber Art by Rosemary A. Thurber
Illustration copyright © 2006 by Marc Simont

All rights reserved. No part of this book may be used or reproduced in any manner whatsoever without written permission except in the case of brief quotations embodied in critical articles and reviews. For information, address Collins Design, 10 East 53rd Street, New York, NY 10022.

HarperCollins books may be purchased for educational, business, or sales promotional use. For information, please write: Special Markets Department, HarperCollins Publishers Inc., 10 East 53rd Street, New York, NY 10022.

FIRST EDITION

First published in 2006 by:
Collins Design

An Imprint of HarperCollinsPublishers
10 East 53rd Street
New York, NY 10022
Tel: (212) 207-7000
Fax: (212) 207-7654
collinsdesign@harpercollins.com
www.harpercollins.com

Distributed throughout the world by: HarperCollins*Publishers* 10 East 53rd Street New York, NY 10022 Fax: (212) 207-7654

Library of Congress Cataloging-in-Publication Data

Thurber, James, 1894-1961.

Secret lives of Walter Mitty and of James Thurber / by James Thurber; illustrated by Marc Simont.-- 1st ed.

p. cm.

Includes full text of "The Secret life of Walter Mitty."

ISBN-13: 978-0-06-084788-3

ISBN-10: 0-06-084788-3

1. Imagination--Fiction. 2. Husbands--Fiction.

I. Thurber, James, 1894-1961. Secret life of Walter Mitty. II. Title.

PS3539.H94S43 2006

813'.54--dc22

2005024248

Printed in China

1 2 3 4 5 6 7 / 12 11 10 09 08 07 06

First printing, 2006

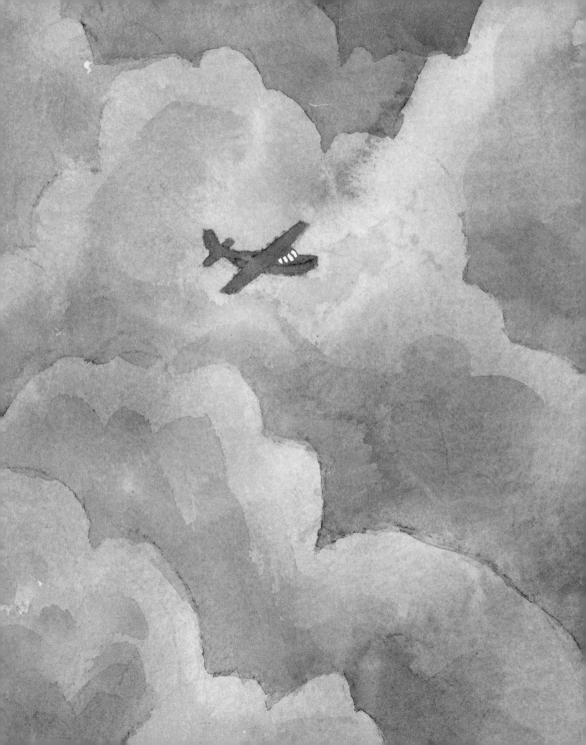